So This is Me

So this is me...I'm a tad wacky and just shy of crazy.

And I love to create. Whether I'm painting fine art in my studio, drawing my wacky characters on location at shows, sitting at my pottery wheel on my back porch, or writing at my computer, the creative process is liberating beyond words. I am forever exploring new ways to express the energy inside me. But I feel forever blessed to have these gifts and vow to never take them for granted.

I'm 50-something years old and live mere feet from the ocean in a funky little surf town called New Smyrna Beach, Florida. Yes, I know. New Smyrna Beach has been officially declared the "Shark Bite Capital of the World," but the sand sparkles like white crystals and the water is a thousand shades of aqua blue. Waking up every morning to this glorious sight makes my heart tingle. I share that space with my husband, Al, and a goofy Labrador retriever named Lucy. I eat chocolate truffles while I paint—and

when they run out, I quit. I drink Perrier sparkling water so often I'm considering taking out stock in the company. I practice yoga, which for some strange reason I think will help compensate for my horrible diet, and I sit on the beach with my toes in the sand every chance I get.

I have five grown children and fourteen grandkids who love me as much as I adore them. I've taught them to dip their French fries in their chocolate shakes, make up any words they want to any tune they like, and to never, ever color inside the lines. (However, they all feel the need to assure their friends that they also have another set of grandparents who are "normal.")

Add the Color... Feel the Tingle

There's nothing more satisfying than finishing a work of art. It adds excitement and joy to your life. Or to use my favorite tag line, you "Feel the Tingle."

The fact is, not everyone likes to draw, but everybody loves to color. Thus, anyone can experience the joy of participating in creating a piece of art with a coloring book. That's the genius of the medium. It's fun, interesting, and very fulfilling.

It doesn't matter how creative you are, you can learn about color and finish a masterpiece worth displaying. That's the purpose of this introduction—to teach you this skill.

If you already know this stuff, have a ball. If you don't, this information is way worth the effort. It will influence the way you color your entire world, from your home to your clothing to your food. Yes, even how you apply your makeup. And you will become a coloring book guru to boot.

So let's begin.

Color Selection Is Critical

You definitely want that "wow" factor when you're finished. So you need to know which colors do and do not complement each other. Do it right, and it will look like a Picasso.

The most essential tool in color selection is the color wheel, presented on the next page. Each color in the wheel is either PRIMARY, SECONDARY, or TERTIARY.

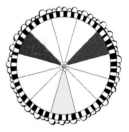

The primary colors are red, yellow, and blue. These are the root colors—they can't be created by mixing other colors. They are the pure foundation of the color wheel. All other colors are some combination of these three.

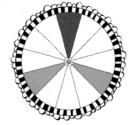

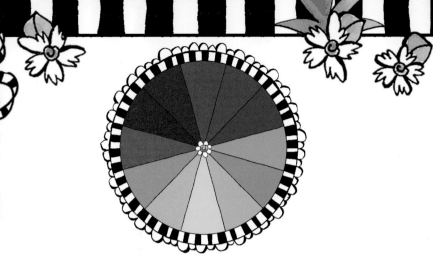

The secondary colors are orange, green, and purple. They are simply an equal mix of two primary colors (red + yellow = orange, yellow + blue = green, and blue + red = purple).

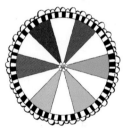

Tertiary colors are created by mixing a primary color with a secondary color. The resulting color is a matter of the percentage of the colors in the mix. There is no end to tertiary colors.

Colors are also categorized as warm or cool. Red, yellow, and orange are warm colors. Green, blue, and purple are cool colors. Selecting warm or cool colors really sets the mood of your piece. Warm colors are bold and exciting, while cool colors are more calm and peaceful.

Things really get interesting when you start playing with variations of a color. You can "tint" a color by adding white to the mix. Or you can "shade" a color by adding black.

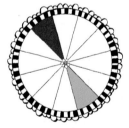

Colors opposite each other on the color wheel are called "complementary" and really pop off the page when they are used adjacent to each other. That's why you see yellow writing on purple backgrounds on billboards all over town. Or vice versa.

My Personal Twist

Since my earliest days as an artist, I have embraced the color yellow. Whether I am painting in my preferred medium of watercolors or dabbling in acrylics, pencils, markers, inks, or crayons, I almost always start with a layer of pale yellow—especially on a piece I want to be on the warm side of the color wheel. This assures that any work of art gets a wash of sunshine, whether the final colors are green, yellow, orange, or red. It really makes the colors pop. Greens get limey, oranges get a tangerine glow, reds get fiery, and yellows get even more electric.

And don't forget to leave open spaces with no color for white. It's easy to want to color every single nook and cranny with one of your fun colors, but leaving enough white is just as important to give your finished piece a lovely balance.

Celebrating the Sisterhood

Your Time Has Come (mini), Color by Tiffany Nizzario
© Suzy Toronto • suzytoronto.com

The Power of Girlfriends (mini), Color by Tiffany Nizzario
© Suzy Toronto • suzytoronto.com

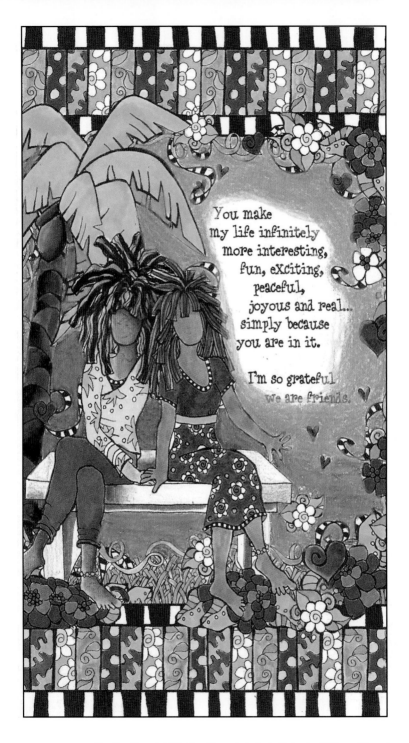

You make
my life infinitely
more interesting,
fun, exciting,
peaceful,
joyous and real...
simply because
you are in it.

I'm so grateful
we are friends.

I'm So Grateful We Are Friends (mini), Color by Tiffany Nizzario
© Suzy Toronto • suzytoronto.com

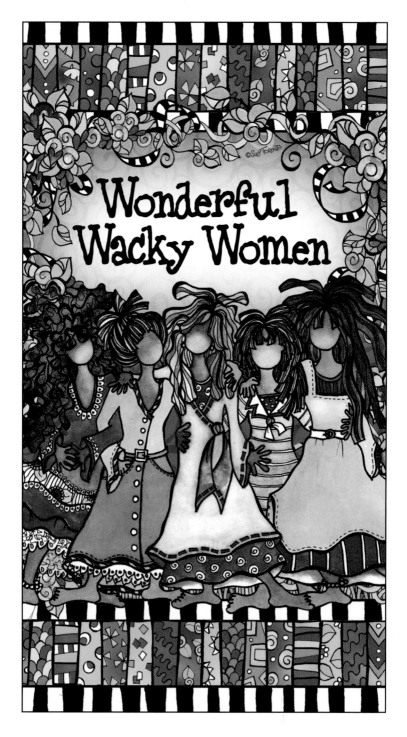

Wonderful Wacky Women (mini), Color by Suzy Toronto

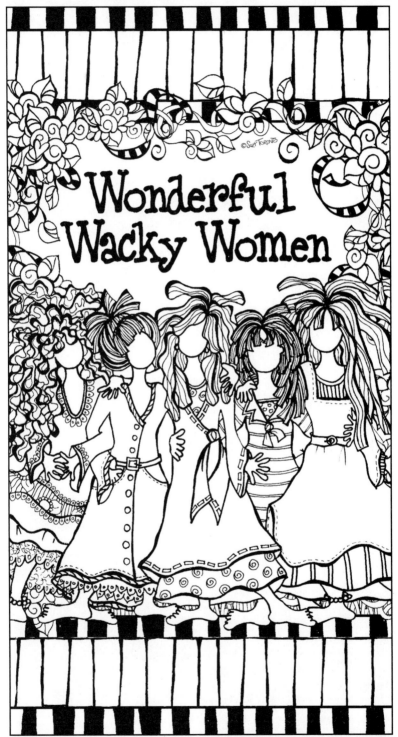

Wonderful
Wacky Women

One laugh, one smile, one hug—
one great sisterhood of wonderful
wacky women.

Wonderful Wacky Women (mini)

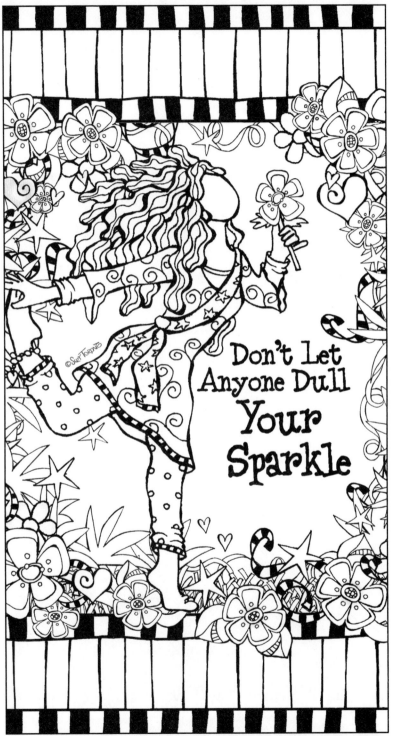

Don't Let Anyone Dull Your Sparkle

Go ahead—break the rules! And whatever you do, don't worry about staying inside the lines.

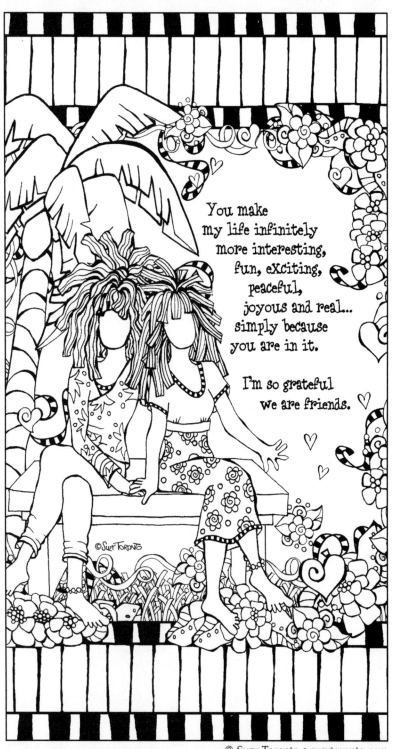

You make
my life infinitely
more interesting,
fun, exciting,
peaceful,
joyous and real...
simply because
you are in it.

I'm so grateful
we are friends.

You make my life infinitely
more interesting.

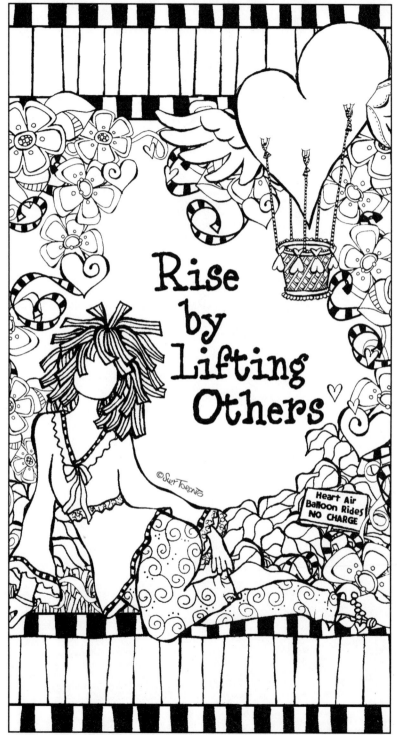

Rise
by
Lifting
Others

Heart Air
Balloon Rides
NO CHARGE

©Suzy Toronto

Today, give a compliment to a complete stranger. It will make both of you smile.

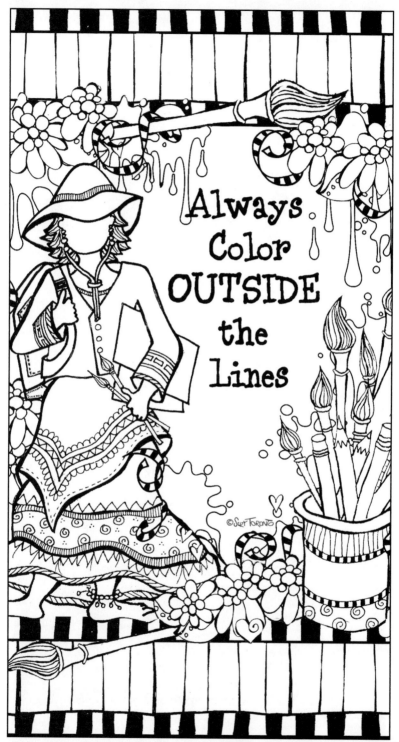

Always Color OUTSIDE the Lines

© Suzy Toronto

If you want to make a difference in the world, do it by being different from the world.

Color Outside the Lines (Sisterhood, mini)

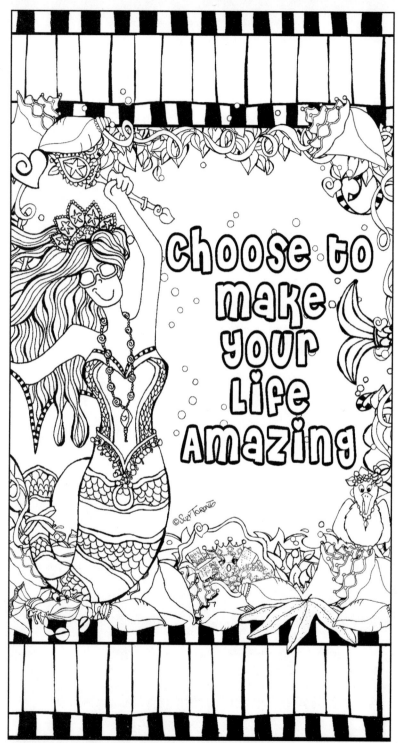

choose to make your life amazing

Thinking bigger will make
all the difference.

Choose to Make Your Life Amazing (mini)

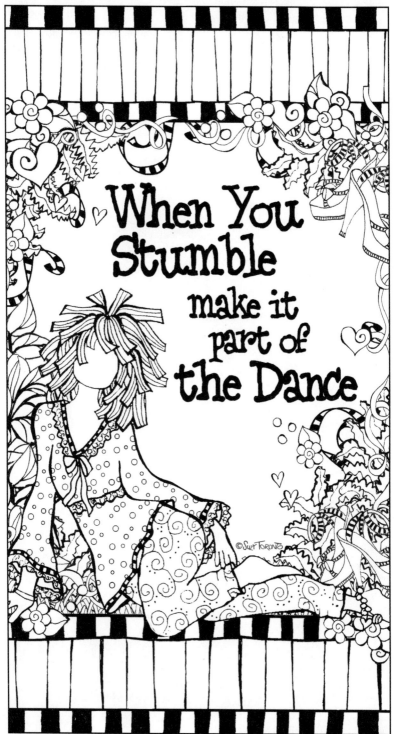

© Suzy Toronto • suzytoronto.com

When the world around you starts to dim, you must find the light within.

When You Stumble (Sisterhood, mini)

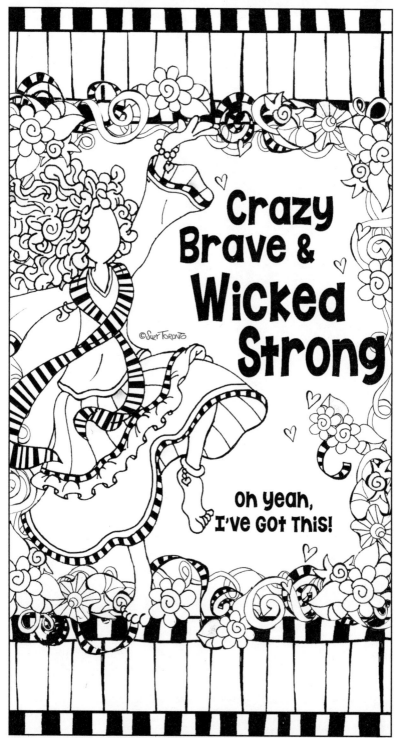

Crazy Brave & Wicked Strong

oh yeah, I've got this!

©Suzy Toronto

It's time to become the person you were always meant to be.

Crazy Brave & Wicked Strong (Sisterhood, mini)

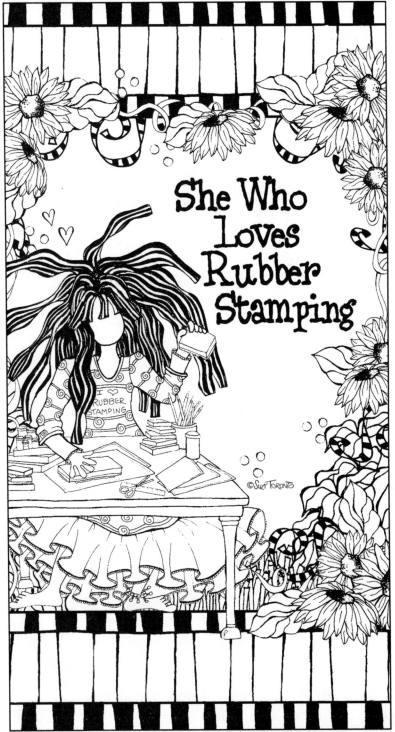

She Who
Loves
Rubber
Stamping

All great ideas start in someone's craft room and are preceded by waves of chaos.

She Who Loves Rubber Stamping (mini)

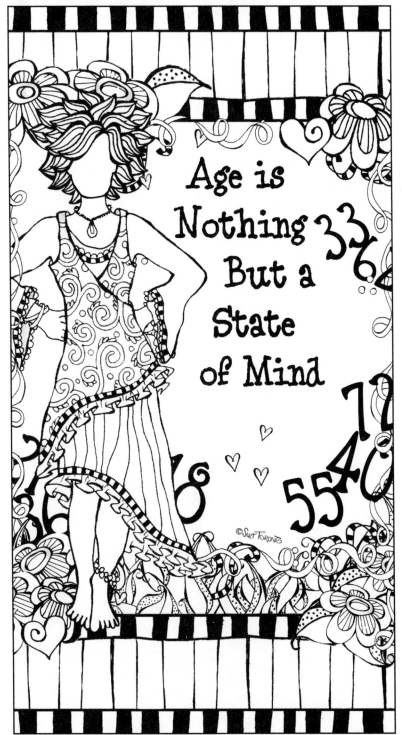

Age is Nothing But a State of Mind

© Suzy Toronto

We're only as old as we feel, so it's best to stay lost in bewilderment.

A State of Mind (mini)

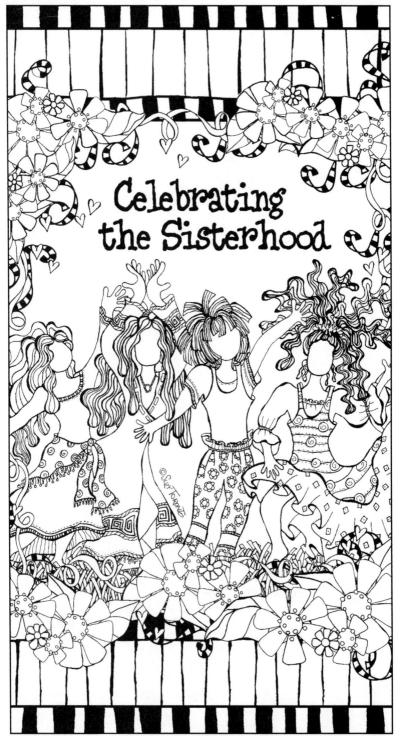

Celebrating
the Sisterhood

We are sisters by choice...
not chance.

Celebrating the Sisterhood (mini)

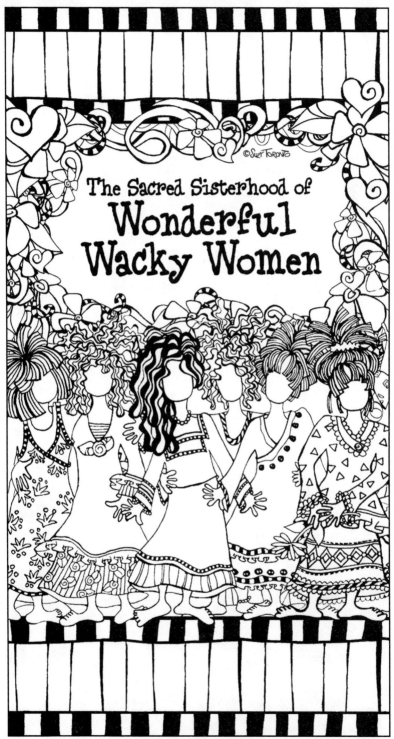

The Sacred Sisterhood of
Wonderful
Wacky Women

Wacky women are the fabric of life that has the power to create a better tomorrow.

The Sacred Sisterhood of Wonderful
Wacky Women (mini)

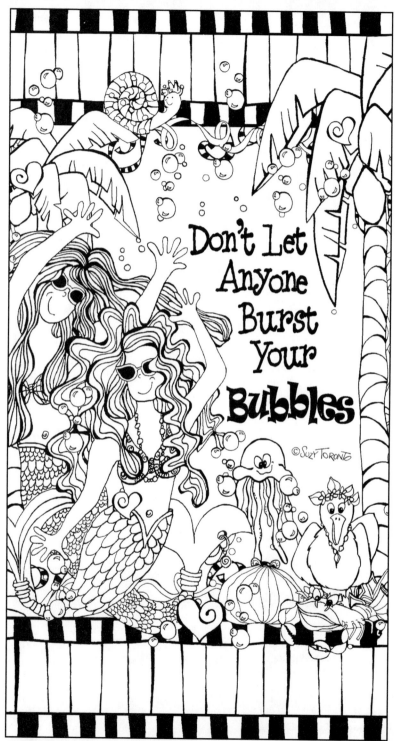

Life is full of endless possibilities.

Don't Let Anyone Burst Your Bubbles (mini)

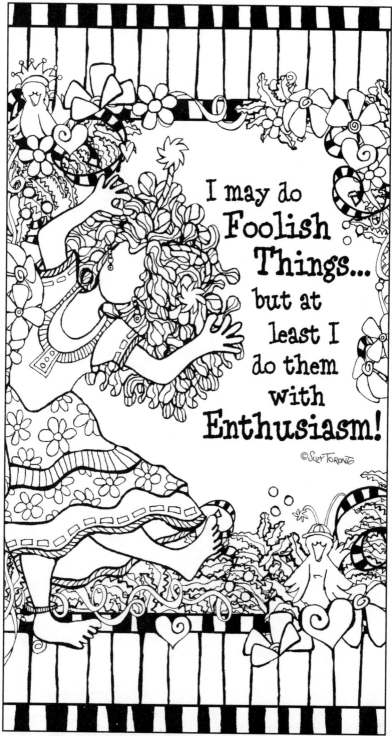

I may do
Foolish
Things...
but at
least I
do them
with
Enthusiasm!

©Suzy Toronto

Some days I like being a fruitcake.

I Do Foolish Things with Great Enthusiasm
(Sisterhood, mini)

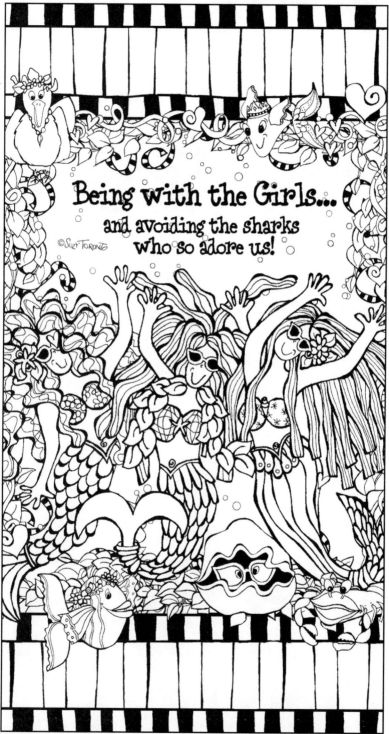

Being with the Girls...
and avoiding the sharks
who so adore us!

©Suzy Toronto

There are no limits to the things
we can accomplish when we're
supposed to be doing something else.

Being with the Girls (mini)

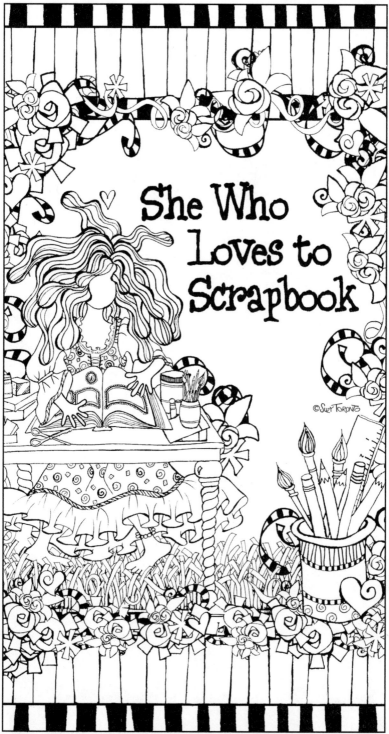

She Who Loves to Scrapbook

© Suzy Toronto

You can make a difference in
the world with just spit, glue
and duct tape.

She Who Loves to Scrapbook (mini)

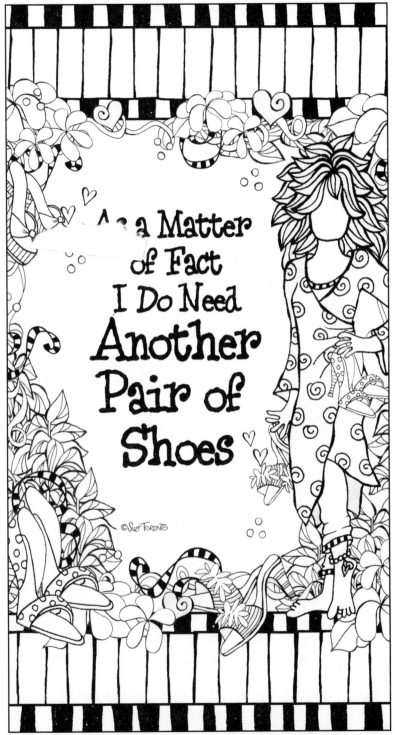

As a Matter
of Fact
I Do Need
Another
Pair of
Shoes

©Suzy Toronto

Flip-flops don't count when he says
you have too many shoes.

Another Pair of Shoes (Sisterhood, mini)

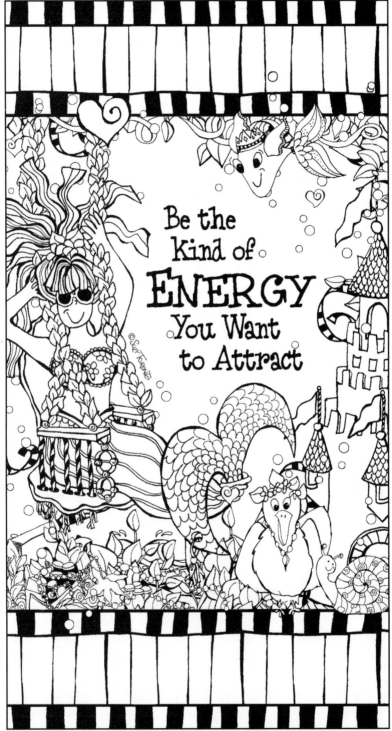

Be the
Kind of
ENERGY
You Want
to Attract

© Suzy Toronto • suzytoronto.com

Make your life and your actions a
story worth telling.

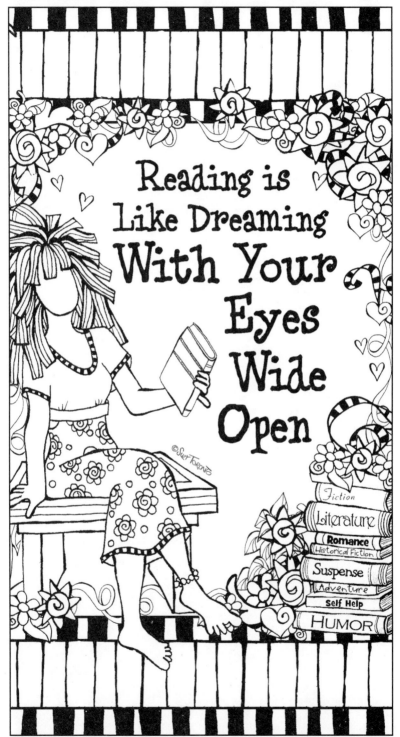

Reading is Like Dreaming With Your Eyes Wide Open

Fiction
Literature
Romance
Historical Fiction
Suspense
Adventure
Self Help
HUMOR

© Suzy Toronto

Dream in colors that do not yet exist.

Reading Is Like Dreaming (Sisterhood, mini)

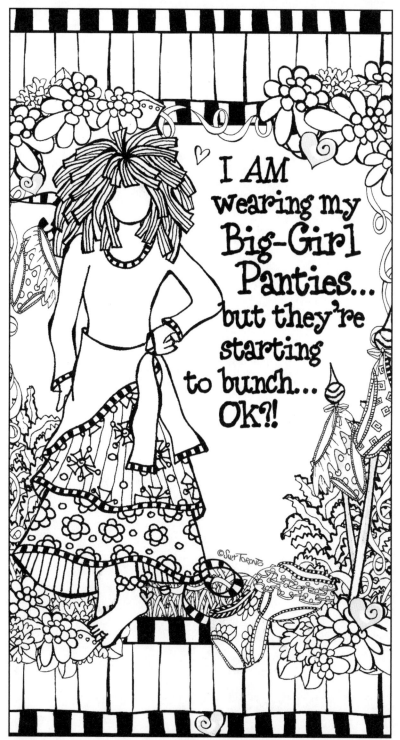

© Suzy Toronto • suzytoronto.com

Don't get your panties in a bunch.
Nothing is solved by it, and it just
makes you walk funny.

Big-Girl Panties (Sisterhood, mini)

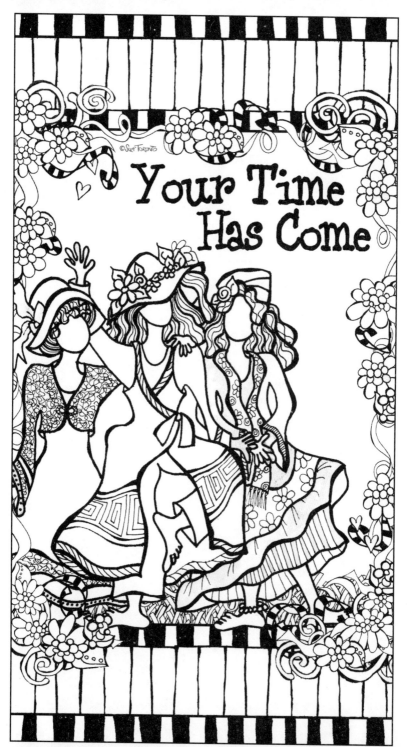

Start each day like it's your birthday.
Make it ridiculously amazing.

Your Time Has Come (mini)

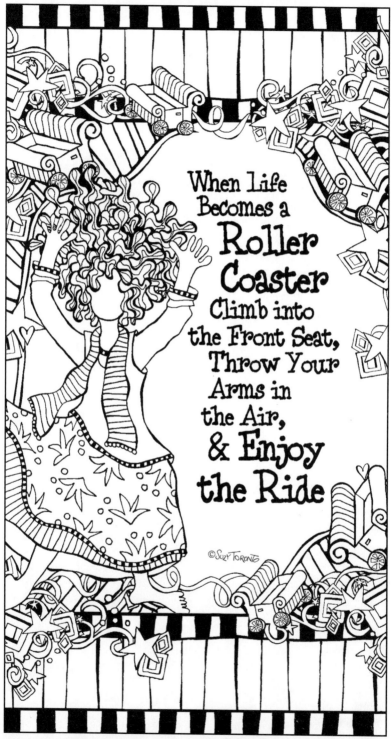

When Life Becomes a **Roller Coaster** Climb into the Front Seat, Throw Your Arms in the Air, & Enjoy the Ride

©Suzy Toronto

Be open to whatever happens next.
Be flexible. That way, you never
get bent out of shape.

Enjoy the Ride (Sisterhood, mini)

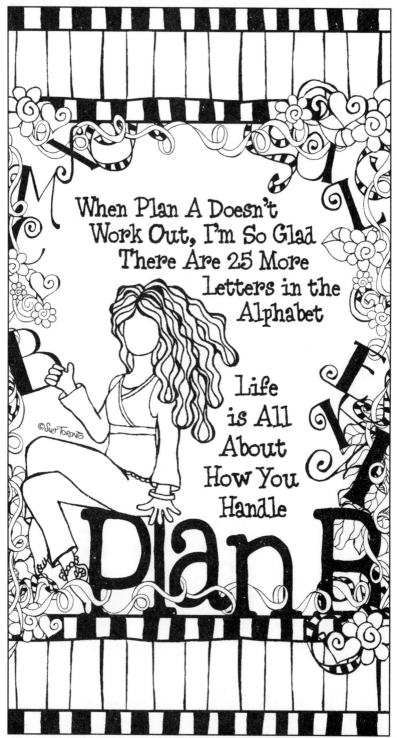

When Plan A Doesn't Work Out, I'm So Glad There Are 25 More Letters in the Alphabet

Life is All About How You Handle Plan B

© Suzy Toronto

Life is not a journey, or a destination.
It's an adventure.

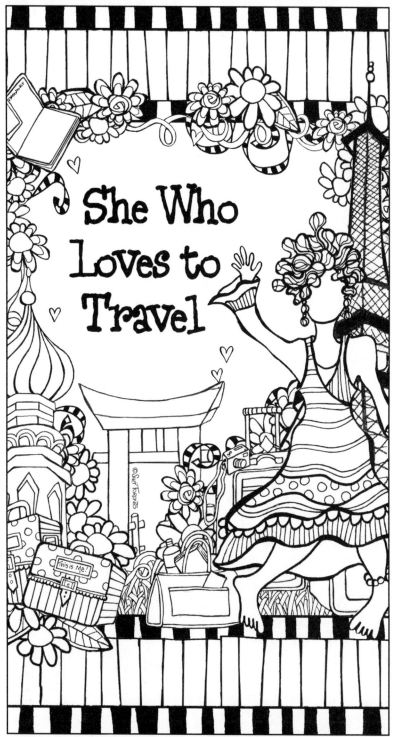

© Suzy Toronto • suzytoronto.com

Lead with your heart. It will never lead you astray.

She Who Loves to Travel (mini)

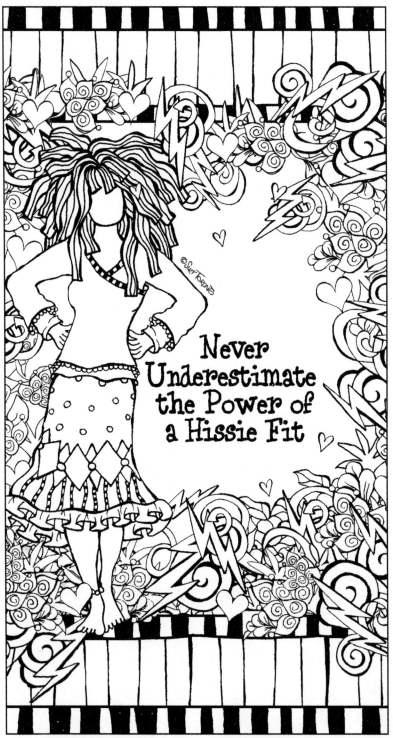

Never Underestimate the Power of a Hissie Fit

The noblest thing you can do is stand up for what is right. Sometimes you have to throw a few lightning bolts to be heard.

Hissie Fit (Sisterhood, mini)

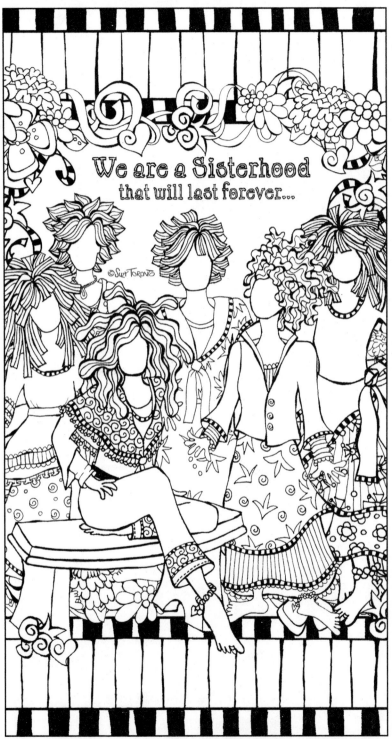

We are a Sisterhood
that will last forever...

© Suzy Toronto

Our bond is stronger than anything in this world. This is how sisterhood should be.

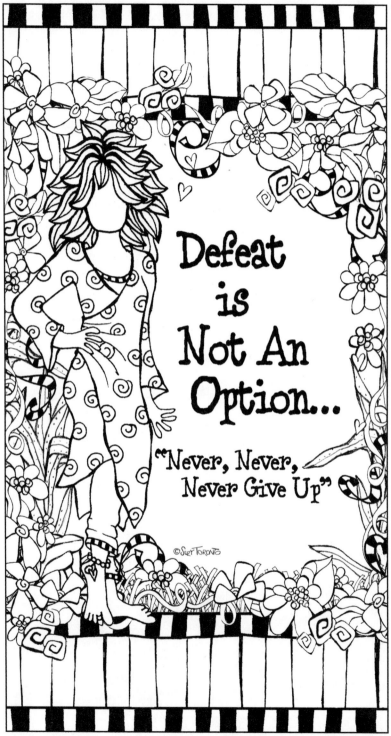

Defeat
is
Not An
Option...

"Never, Never,
Never Give Up"

©Suzy Toronto

If you want rainbows, you gotta have rain. The trick is to put on your boots and go looking for puddles to play in.

Defeat Is Not an Option (mini)

Through triumphs and trials,
we leaned on each other.